Peripheral Vision

Carl Gomez

Grosvenor House
Publishing Limited

This book is published by
Grosvenor House Publishing Ltd
Link House
140 The Broadway, Tolworth, Surrey, KT6 7HT.
www.grosvenorhousepublishing.co.uk

A CIP record for this book
is available from the British Library

ISBN 978-1-80381-110-9

For my family, whose love I cherish

Contents

Tiger at bay

Let go your bag
The phone in its coloured case
The keys to your house,

Leave your tight wallet
Receipts and notes
Park your car
And walk away.

It moves through the forest
Through the slatted shadows
Bright clearings
Midnight scrubland and tall grasses

It leaves a print
A still bloody carcass
Ordure and scent,

It can walk lightly
Only the paths of its mind
Bring it back to belonging

To the familiar, the known
What you may call home.

Horizon

White blossom whispers
Moved by fair spring breezes
The dominion of winter
Remembered in cold black bark

Grown to its fullest extent
Drenched by passing lorries
And rocked by their thunder
A periphery, a no space

Claimed, and now sung of,
With each opening petal
And dreaming of fruit
Petals gazing into the white face
Of a passing winter.

Spring has come once more
Once more the world renews
Once more we shift beneath the budding leaves
Along a path we have never trodden before
That we will remember even so.

Rain

Rain, falling in the wood
Pines drip lines of silver water
Susurration of soft drizzle,
The air heavy,
Freighted with the burden
Of clouds, whose rolling march
Fills this April sky.
New born lamb faces gaze
As a mother heavy with milk
Watches me pass:
I drop my head
As the land drops away,
Below the fertile valley earth
This rain, rain, rain
An exhalation.

We wake, we die

1

A moon-like circle
Orbited by barren rocks

Your face gazing into a shop window
Dreams of the unobtainable

Those bare feet climb
Followed by cloven hooves

All this can be yours
APR 19.3 %

Or affordable lease/hire options.

2

At my setting out and at my return
Tottering beneath your guiding hand
Or caught as I fell,
Reminded by the earth how hard she is-
Your dreams on me will founder
When you wake, when I wake you
When we wake together
Our pressed lips pulled apart
Our bodies consumed
As if in fire
Our orbit, ash

Only once

Only one occasion would it need
To remind of a power immanent.
Only once overturn all the usual signs
Our compass and guide
All the futile lies.

Yet as a child wondering what potent
Magic or god or anger
Caused this rupture, fearfully sent,
Was it already a side of dialogue
We had blocked to silence?

Today I can only bear witness
As thunder shook the fragile frame
Of our cosseted right to exist

If she chooses, we will be shook off,
Unconscious in the ignorance of our bliss.

Janet

You may imagine this a play:
A play

And we the players
A skull handed carefully down,
Medicine to cure the incurable
The intransigent.

It is freedom as expressed
By the desire to sit alone all day
Lost in a kind of waking dream,

Some regret, some hurt too deep
Hoping the flickering, flashing light
Will illuminate the dark corner
Or run as from an unwelcome dawn
Back into a darker corner still

I closed the curtains abruptly as they took you away
(Not much of a metaphor)
For those wheels are real
As is the pain you feel

And now I too sit alone in silence
My phone beeps, a weather report perhaps
The shape of the day leading here
Tomorrow only a supposition
I wait to see that which carries you home
Here, for you are missed.

Hanami

Life and the remnants of life,
A record of passing.
Spring breezes move through branches
Dun leaves rattle, clinging to young oaks
Shaking and twisting as buds start to break.

A puddle reflects the grey-blue sky
Rosy stones lie half covered,
Decay works sodden leaf and wood
I wait; the steep way past
The path slows and widens
Sloping by the sighing pines
Cypress, cedar
Ties the criss-crossed trails
To dual thread of weft and woof,
Leading back to my beginning
And on to an end.

Two-wings

I sit beside the cold window,
You rest on the chill-paned glass
Like you, I am prey to the unknown
Flash of predator darting past

I avert my song filled gaze:
Who knew that time would slowly come
From dark doorways of childhood days
Running, flying headlong on.

Out of the corner of my eye
A shuttle of relief that hides
The pain from view, till beside
A record of lost years you find

That buried ghost has resurrected
Or better, showed it never stopped
Directing your steps. You may regret
A choice, the pact you forgot

And now comes the dead reckoning
Prostrate, cold, willing, wanting to live,
Yet it is late April and like the sea
The air tide promises only to freeze.

Spring coils in a furled leaf
As your thoughts return to dreams of youth
That seem now out of your reach
As the weight of this false winter's truth
Settles its heavy, deathly score.
We will hope for days to transform,
For the welcome of renewed life
For the courage and strength to face this strife.

Inter alios

First step intercellular
Then inter-systemic
A cry
Interpersonal
Impersonal
Interrogation
Close exchanges
International

Inter alia
Intra-orbital
Let's do some maths

Interplanetary
Time slowing right down
Right
Down

Dawn on Mars
Drawn to Jupiter

Interstellar, Vega
Intergalactic, Andromeda

A neat sidestep
For one so large
Interdimensional, Inter-universal
Stop, please
Stop.

The fourth door

You have known the tug of the breeze
Coiled in your code

High above the streaming earth
Wind-blown, carried for untiring miles;

Now your rest is here
Your roots deep tap
Between the muck and the sun

Earthed like a conductor
Holding tighter than this urgent grasping;
You may break
But a scrap, a fragment of yourself
Is too deep for this violent pull

You grow once more
Where the grasses grow tall
Where the deer trails cross

And reach once more for the clouds
Your erstwhile home
Yours the many petalled sun.

The Crown

Shook awake in darkness
As a storm tore through

Not till the afternoon
Do I venture out

The road scattered with fresh leaves
Snapped twigs and branches

And here
The trunk and crown
Shaken, shifted and shucked
From its earth mooring,

Casualty of the winter
Or perhaps fallen years before

I look into the spring sky
A distant grey front of drizzle
And the sun's face obscured in cloud

Consequence lays heavy as the wood
And this rain spattered coat
Slight protection to my still worn bones.

Comedy

Years lost in a moment
The dreadful weight
That this moment destroys
Those which precede
Those which follow

Moving forward into the past present
A stasis
Is this all that I am?
This horrified certainty?

And a creation without a maker
Yesterday's cosy dream, a garden
Of pitiless struggle
O fear will you ever leave
Joy exhausted?

Yet
We condemned, those prey
To this struggle to survive,
Reach out too
To give comfort and hope
Because as he says
All we have is each other
Surrounded by a cacophony of stars
Skirting unknown regions of space
Flying into the void
Together.

The imposters

We stand in sunshine, dig the broken earth
The wind swings from the North, its Arctic chill
Reminds me of a seldom trodden path
Beneath the trees, a glade beneath this hill.

Our hands were joined, alive we watched them grow
From childhood's hiding place. That secret den
Whose walls are wooden bars, whose floor below
Is where we learned to track the misted sun.

And like the sunrise he appeared, that day;
Our nets were empty, vacant clouds went by
We prayed our store would fill, as children pray
For joy and comfort, peace; those fears allay.

Yet we walked on and burdened soon forgot
Those unforgiving words, that soft command
That urged our hearts' forgiveness, soon forgot
Our purpose and our empty yield, like men

And women locked in darkness; jailer's walls
The wind-blown grass; jailer's calls the blackbird's
Song; till with heavy hearts as last recalled
The hidden key in harmonious words

Like love and courage, trust and honesty:
Like jailers, hurt we feel until the day
The wind moves through the grass and blackbirds fly,
Our prison's shadows fade, until our hearts are free.

The Suns

I hold these scales
Twin suns in an azure firmament
Closer, closer still
The lesser weighs heavy
The greater unexpectedly high,
Massive, dense, yet
Insubstantial.

In the darkness,
The memory of its past glow
A million years before, photons
Returning to their source

Through and on to fall
On another globe;
The hungry grasp of an opened leaf
Locked into a knot
The swelling of girth and then
Reaching, straining, dying
Falling, falling to earth.
Woken at the crack of dawn
Hands searching for the light
In the dark, kneeling, candlelit
A shower, a distant falling
Lights the rise.

The fall

Deceived in a dream
Waking to the truth
Of my self-righteousness.

Choosing a path
As hundreds who walked this way
Chose too,

It seems so fragile, insubstantial
As if a long winter
And a riot of spring
Would erase it -
It skirts the crown of a tree
Close, as if seeking comfort, security.
And then I am sat facing your bruised face
Despair close in your sighed tone-
One day just like any other
Losing track

And your face,
A retinal shadow
On a pale wall

My eyes follow the line cast
Like an imprint,
Your warmth, a shared complicity
A shade in which we rest
Which sustains for a while
As the sun crosses the trackless sky.

Puzzlewood

The fist in the green leaved glove;
They wait
Watching themselves reflected
In a thousand eyes.

O how can I spread these wings
Move
The green valley of my thoughts?
How cross the muddy briar
Where sheep graze
Where crows mob the hawk,
Journey to a forest
My soul remembers
The soil I remember?

A wave rolls through the light
Tempest rolling in
A storm pulling at the roots
Of the seas, surged swell.
Here you could forget the deep
The fathomless, fearful drop
Here, float at a beginning
Grown old once more
A dream of release.

For what separates us
You like the blackbird hen
An eye haloed in amber
And I
A thought away from you?

(the unfolding steps of a jailer,
the seventh wave,
the pull of the full moon
and deep tidal shift)

I watch the slanting bars of sunlight set
And hope that when I wake
In the pitch inky dark
The sounds of the trapped and caught
Will be a choir in song
Anguish now exultation
Love not fear will right a wrong.

Earth

Stretching downwards
Into the cooler earth

Sun scorching the rough grasses,
I can measure a path
Across this ground:

Where there is emptiness,
There I am
The shadow of my former days

Lies in the bright sun.
Calling to those hidden seeds
Strange roots, white lines
Fibrous, tangled toughened,

Irrepressible, a growth
More ancient than sea stones

The emergence of unstoppable life
The fact of this, this
And its end.

The lights

The lights are slowly going out
What is left
Is not darkness opposite
But an absence of light.

At the very end
In an endless evolution
Robbed of chance and change
A void

Tiger shapes in a rainy mist
A pilgrim's empty prayer
To their tired steps
Pulled to the roadside
Hooded by overhanging branches

From the top of the tallest tree
A single egg
Falls.

Limit

Hunched against the morning cold
Cold of last night
Claws gripping the windy branch
Memory of summer heat
Anticipating winters icy grip.
Strife forgotten
Or at least postponed
For we warm here together
Our struggles shared
For the moment:
We will fight again
For this sunlit garden
For the promise of spring's return
And the increase it brings.
The fuse deep in millennia,
Driving the lift of my wings
The steel in my eye
Our struggle, a shared calling
Our pattern and fate.

Heron

Looking from the rattling window
Sunlit banks and the murky
Glow of lit river water.
A heron
Disturbed by our approach
Takes slowly to the sky
To the safety of empty air,
Circles as we pass
To settle once more.

Its stillness a hunter's guile
Where will it fly next,
From this field of browsing cattle?
Marking passing years
By the river's swerving meander
Its gaze an ancient reckoning
From a time lost in obscurity
Before we cut this path
Laid these tracks
Before our violent birth.

Gilgamesh

From the ridges of my forearm
To the delta of my wrist
And hand
Fertile soil spreading like fingers
Life carried by vein-channels
Blood rich silt.

These hands put to use
To mould and form
Fern and maelstrom,
Storms of blown trees
Typhoons of slanted rain.

Hooves mark the passing
Of civilisations temporary rein,
Of the next despot
Tyrant, conduit, valley floor.

An open field

An open field of shifting wheat
Cut by our incessant desire
Now complete, a circle closes
In the flames of a circling fire.

"Hear us roar our song of fear"

On this rock bed let us build
Monuments to a hidden greed
Where flower heads give up their yield
Let engines run and petrol bleed.

"Hear us cry our scream of pain"

As we venture into the day
Once more, the sky lit, full
Of our expiring dreams, we say
No more as vassals to their rule.

"Hear the thunders solemn clap"

With marching feet, we close the way
With voices raised in struggles grip
This will not pass, no not today
Our precious world we'll not let slip.

"Your power finds its limit here
Your strife, your greed, your fear"

The butterfly sips

What would it take?
A will resigned to its own courage?
Belief of some sort?
Treading the powdery ash of an ancient burning.

Did you look back?
Did your spirit sink as it felt
The crushing weight?
Years of success, trials surpassed
Patient, dedicated longing
To prove to be the line
Tracing against the blue-black sky.

Earth cloistered
Bound to the drudgery and despair
Hope and desire

To risk all this, as the clouds
Cross the face of the moon
And light leaches from an ending day

I write in darkness
My words cross a bidden void
Come back to me, my love
Come back to me.

Embers

Driving home with the twins in the back
Ready to compete, we are so excited,
All that is great, sparks
Igniting a fire from bare kindling.

Stripes across your head
Like flutes of flame,
Scarf, shirt, crucifix

You brood, and they grow
As they rise, their prints in yours
Until the path forks

And your tear-filled eyes wonder
At the flight of the tyrant time
To a conclusion always known

As much feared as expected;
But there is a knock at the door
A smile, their hands clasped

Your two smiles form circle
A swell of budding
And embers glow still amongst the burnt ash.

Something terrible

Something terrible happened today
In the lit darkness
In a breathing space

In a moment of sudden reflection
Somewhere:
And yesterday,
And the day before that,
And that too.

Tomorrow is the shadow I write into
Where words chosen to seek
Are raised and emerge
Into electric light

A line surprising itself
Horrifying itself;
As long as I hold this pen
As long as I write

That darkness will be written into
And fallen over
Guessed at, not wanting to know
Needing to know

Are you asleep?
What heaven could contain such horror
What hell such hope?

The ripe fruit

You collected the ripe fruit
And I stood at my stove
As the days closed in.
Sunlight fading, not cold
But the year was drawing to a close.

I remembered your smile in the Spring
As we sat in the blooming orchard
And the sudden fear in your face
Like a windswept cloud crossing the sun,

They will never (not a word you used)
Let us be free, their iron fist
Closing like a sharp trap.

We held our breath as a car drove by
Knowing the fear that love hides
If it was just us, we could cope
But they never stop.

It was not on tv

Like the trunk of broad trees
Like blood vessels branching

Like a shaded grove of oaks
Fir and cedar, ash,

There they take flight and flee
As the metal cuts and razes,

Pale ministers of grace
Spirits protective of this place.

They tend and guide
Gathered in life giving shade

The sword passes, and in its wake
Bare soil, stumps, a potent void

Filaments finer than silk
Spread and break
As the earth reclaims herself

Winter calls from his green hill
His ice freeze and chill
His cold a measure of your will.

Longboat

This half-withered leaf
This early autumn morning,
This longship, timbers decayed
Disintegrating beams
Lit by the low sun.

You
Cannot sail me now
Their arms cannot heave
The rising tide streams,
I wait
The weight of your form.

This harbour, a shield
Breakers roar and bellow
A cliff
A sheer drop
Who do you want to believe,
A prisoner or one set free?

Pride

It starts with warm hands, held
It ends with an iron gate pushed to.

In between
In a precious moment
The toothless, the homeless
The misunderstood,
Those young lovers kissing
As guardians oversee;
The desperate, the newly hopeful
Confused in confusion,
But at heart, here, now
There is love
And for this slow revolution
Balance is restored

Here is the mask I wore,
Take it.
And here the discarded
That we carefully collect
Before the gate swings to once more.

Before the shortest day

Eyes that once held joy, instead
Downcast, as if gazing at the very edge
Of this life, at the drop, where fear
Blinds and memories of possible
Futures unfurl in a record of the past.

Yet that once distant hope succeeds
Here, for her, with a scribble of hair
And a list of those loved ones
A daughter or niece
A son, husband, grandad.

Gathering towards a single day
An unlikely outpost of promise
In the deep of this encircling cold;
A crow called from his tree top
And they circled once more
As one, the body renewed
With the remembrance of a path,
Shadowed by those that once soared here.

Storm Rising

It could be a massacre
Smoking ruins, glowing embers
An absence where children played

It could be the well fed
Benificent millionaires networking
Under strung up lights.

It is this road that curves back
Upon itself, the parked cars
Lit bedroom windows
Fire-flicker of screens
Through parted curtains
An acceleration of noise
Then silence

Above the yellow-grey humps of clouds
Hide most stars,
They look down, will bring rain
Float serenely on, dissipating
Or join a storm front
A gale at their back in darkness
To tear the sea-waves tips
The lonely tankers freighted
Until spent.

At dawn I will look up again
Remember their split moonlit flight
Distant above a fissured earth.

Serendipity

...And
There will also be horizons
Sails caught by the wind dipping,
And slowly
Revolving as it rises and sets.
And yes,
Yes, there is a Spring,
Looked for, hoped for
Inevitable like the sun's slow rise
Yet doubted, surely
Winter's reign is beyond the passing of time?
In the night the sun is forgotten
Moons reflected in water sing its lament
Remembering in their pale glow
How it shines now!
Through the branches of a bare tree
Roots potent and full
Waiting to unfold, opening its leaves like a palm
The rain touching gently
Nail like sting of hail
A muffle of snow.

I wait as you wait
Queuing patiently at the office door
Passing the time of day
The warmth on my neck
On this earth, your earth
Ours.

A breaking wave

A breaking wave,
Salmon writhing as they leap
From one closed world
To an echoing, rock strewn blue heaven.

So, we will count now
Those first raindrops, slowly
Obscuring the dun road
And wintering verges.

The tail of a machine age
White eyes glaring in the storm
In this early twilight
We, both damned and saved
Lit by a red light
Taken along this path
Our disasters uncertain
Destinations guessed at.

Above a rain-soaked rock
He hangs, a metaphor
For our humanity, and nature's
Insistent struggle.

But as the night clouds drop
Their soothing veil
We sleep once more
To wake in the claws of another day.

Berries

As the wind turns
Blown on the tempest,
Flying on wing
In the snow filled air.

Blown over darkened sea
And marsh
Sleeping lit cities,
To be becalmed
Dropped with the gale
In this backwater.

Red berries glowing
Like the winter sun,
So far to return
We must go on.

Winter 1

Into the black
Searing angel eyes
Blind me

Are you watching over
Or judging?

I hear your strange tongue
The sideways mutter
As I feel shifted

At the periphery of
A vast mechanism
Of incredible design
Or chance.

They stand hunched
Down turned faces,
Light spills from open maw
Opened eyes

A gentle nudge
An ungentle maxim
Pools of darkness
Between pools of bright

Snake

She reaches upwards
As he reaches down,
Little did she know
The stars' firmament
That stellar glance
Had one ripe thought behind -

You will not carry this alone -
He seemed to say
His tongue like an adder's back
Diamonds glowed in the teeth
Of his smile

Of course now we know,
Now can measure the desert
From this eagle's perch
The oasis with its barred gate
The pools of water, clear and blue
The waiters only too happy to refill
Your empty flute.

And at home the television shows
A glimpse of a simple paradise,
He snores on the sofa
She cries, hemmed in, baulked,
The trammeled way
Quiver of recognition
As she sees its tail disappear in darkness
Through the night window.

And it follows

1

Open eye
Gone blind
Shattered, shuttered
All seeing
Not knowing
Unable to connect
A play
Within a play
One script fades
Another degrades
Dissolution
Depraved
A salutation
In recognition
Cognition
Cogency
Consequence.

2

Take one and fly
Spread your wings wide
Shouldering the cold air
An exultation of movement

The observer eye
Curious, bewitched
Wondering at your path
Following the beat
The down-push, the rise

A vanishing
A pause
Other hands were at work
Winter's gift now Spring's promise
Your nest is warm
Your heart
Your heart beats.

Sing

Sing poet, sing!
Of bedraggled magpies
Slowly, slowly starving
Of earth parched and broken
Like scorched skin.

Of trees proudly holding their heads
As they strain to breathe,
Their magnificence taken
For granted, their stillness
Masking a death struggle.

Sing of the decision makers
Cowed by the status quo,
Worried for their jobs, their families
As their decisions condemn the same.

Which is worse, the hypocrite
Who stays silent
Or one who sings?
We oversee the demise of that which sustains,
That, without which, impossibility is the only
conclusion

Of course, there will be baseball
And football
In heaven, so hush now poet
Sing the next overhead kick
The next home run
Sing.

Snowdrop

I felt a fear rise, trapped,
I am risking something here, now
I stooped and bent
Captivated by their re-emergence.
How long had it been?
The curtains pulled to
Stale bread, a cough
Their mouths move and I read
Only words.

I thought of you, your face
Your warm hands
As I pulled at the cold earth,
They wilted but the tight nub
Held tight.
I place them here in remembrance
Coiled and cold
Dream of the next winter's end.

A bigger fire

Iridescent beneath the cloudy sky
What purposes do you have?
What unknown path have these wings traced
Searching, perhaps as we all do
For sustenance and something to make us feel less
alone?

A small leaf in a small field
In a small corner of a curving earth,
I imagine intentions beyond any ken
Beyond the scope of the glass and careful columns;
I could observe
Propose and hypothesize
But you will escape the stretch of my intellect
As you disappear into noon-day
And I bend once more.